Zenspirations

Birds & Butterflies

CREATE, COLOR, PATTERN, PLAY!

JOANNE FINK

DESIGN ORIGINALS

an Imprint of Fox Chapel Publishing
www.d-originals.com

Zenspirations® Patterning Basics

The illustrations in this book are designed to be a springboard for *your* creativity—that's why there is a credit line for you, as co-creator, at the bottom of each page. Before you start to color, take a moment to review some of my favorite patterns, which you can use to enhance the designs. In addition to embellishing what's already on the page, I encourage you to express what's in your heart by adding your own text and illustrations to the designs. I've given you step-by-step instructions.

Patterns: Step-by-Step Examples

Four Lines and a Circle Pattern

Step 1 | Step 2 | Step 3 | Step 4

Arch Pattern

Step 1 | Step 2 | Step 3 | Step 4 | Step 5 | Step 6

Triangle Pattern

Step 1 | Step 2 | Step 3 | Step 4 | Step 5

Fence Pattern

Step 1 | Step 2 | Step 3 | Step 4

Leaf Pattern

Step 1 | Step 2 | Step 3 | Step 4

Draw a wide arch and add a leaf on the right side.

Add a spiral tendril to the left side of the arch, below the leaf.

Add a small tendril above the large one and thicken the leaf lines.

Thicken the tendril lines, add dots inside the leaf, and add an extra line to the top and bottom.

Arch Pattern Variations

Triangle Pattern Variations

Zenspirations® Create, Color, Pattern, Play pages are designed to allow your creativity to shine. You can color each page as-is, or make the design your own by adding patterns and embellishing the illustration.

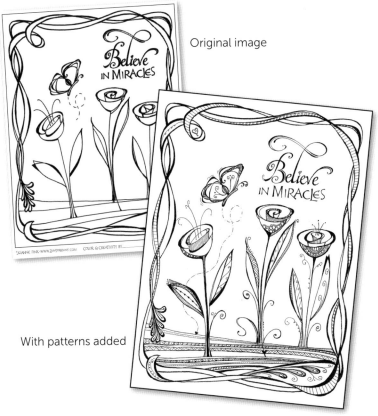

Original image

With patterns added

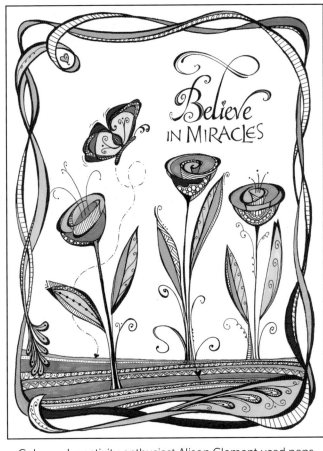

Color and creativity enthusiast Alison Clement used pens to add patterns, then used brush markers to add color to the design.

Adding Patterns: Step-by-Step Example

Here are a few simple techniques for enhancing an existing illustration with patterns. You can add as little or as much as you want—be creative!

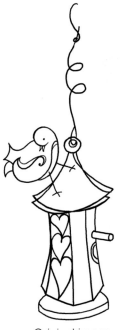

Original image

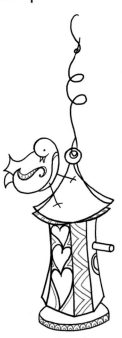

Step 1: Add patterns in the open spaces.

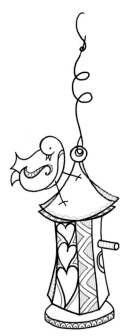

Step 2: Add extra details within the patterns.

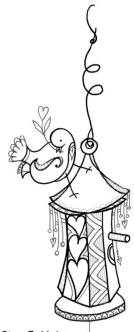

Step 3: Make the design your own by adding on to the existing illustration.

Zenspirations® Drawing Basics

You can use a similar step-by-step method to create additional elements to add to one of the pages in this book, or combine several simple drawings to create your own design.

Try drawing and patterning the cloud, snail, and flower icons below. Notice how they are incorporated into the scene on the next page. Practice creating a similar scene using your favorite icons.

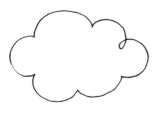 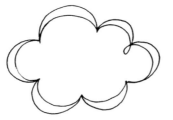 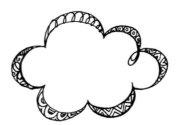 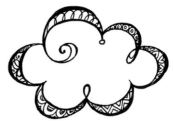

Step 1: Draw the shape.

Step 2: Add lines to create spaces around the perimeter.

Step 3: Add patterns inside the perimeter spaces to create interest.

Step 4: Finish by adding weight to the exterior lines. If desired, enhance by adding your own special touches, such as the spiral, dot, and loops in the cloud and the face and antennae in the snail.

 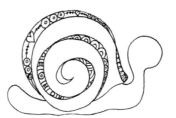 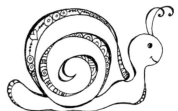

How to Draw a Funky Flower

 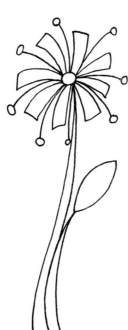 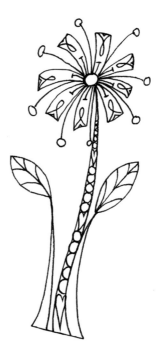 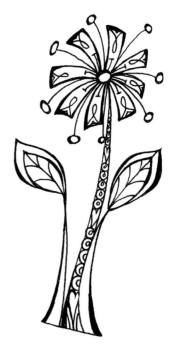

Step 1: Start with a simple drawing.

Step 2: Add a line with a circle at the end between each petal. Add a second line to fill out the stem and leaf.

Step 3: Add small, simple patterns to the petals, leaves, and stem.

Step 4: Finish by thickening some of the lines.

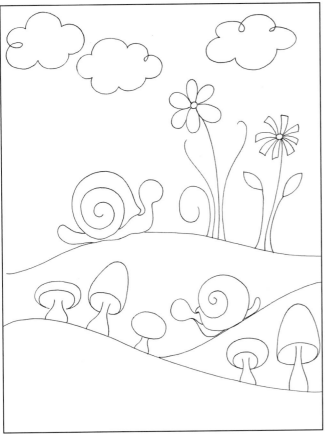

Step 1: Draw the scene.

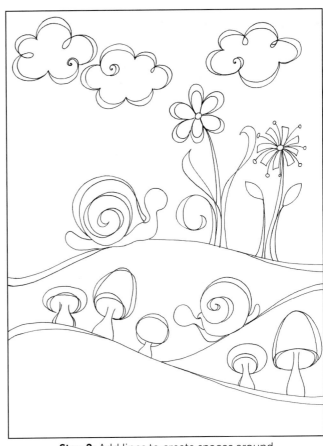

Step 2: Add lines to create spaces around the perimeter of each icon.

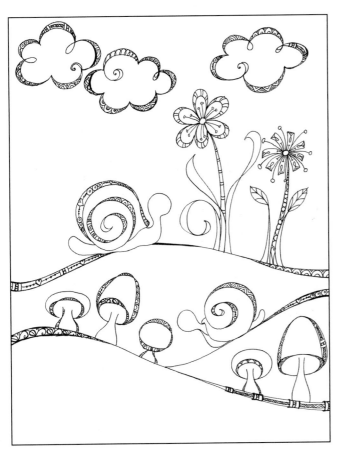

Step 3: Add patterns inside the perimeter spaces to create interest.

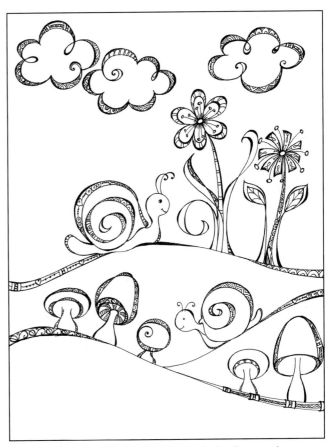

Step 4: Add weight to the exterior lines and finish by adding your own special touches.

Making the Design Your Own

The same design can be interpreted many different ways. You can adapt the designs in this book as little or as much as you want—be creative! Here are some examples for inspiration.

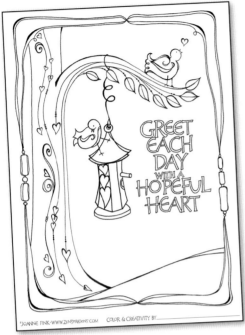

Original image

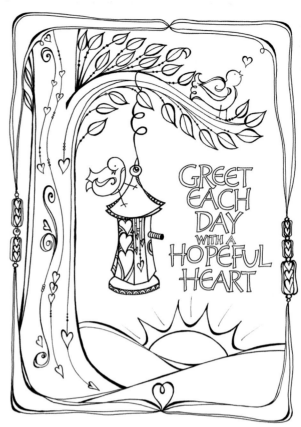

Variation 1: Patterning added to birdhouse and beads; leaves added to tree; hill and sun added to landscape; heart added to bottom border.

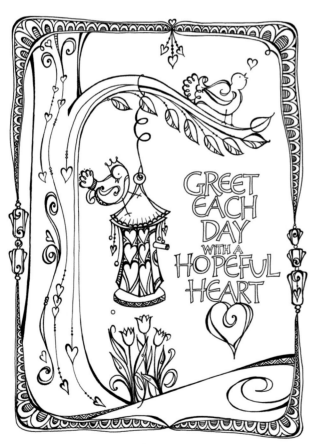

Variation 2: Patterning and dangles added to birdhouse and border; patterning added to leaves; feathers added to birds; flowers added below birdhouse; swirl added to hill; heart added below lettering.

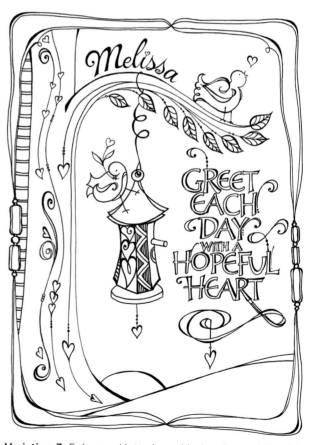

Variation 3: Enhanced lettering with dangles and flourish; name added above branch; flower added in bird's mouth; patterning added to leaves; sun added to landscape; patterning added to left side of tree trunk.

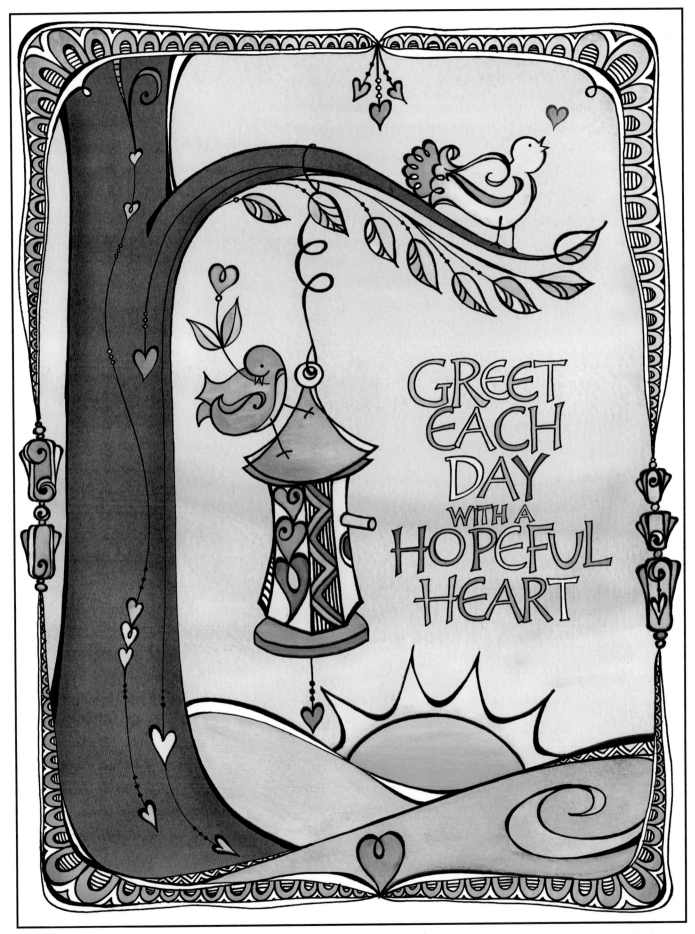

GREET EACH DAY WITH A HOPEFUL HEART

COLOR & CREATIVITY BY_____

Special thanks to color and creativity enthusiast Samantha Trattner for her lovely watercolor version of this design.

Zenspirations® Coloring Basics

The icons on these pages have been colored and patterned using different coloring mediums, each producing different effects. I recommend experimenting with different mediums on scrap paper to help find the ones you prefer before applying them to your designs.

Don't feel like you must color every part of a design. I often leave a few areas of white in my images, especially in the patterns.

Colored with colored pencils. Blended with artist odorless mineral spirits and blending stump.

Colored with water-soluble pencils. Blended with blender brush pen.

Patterned with black pen.

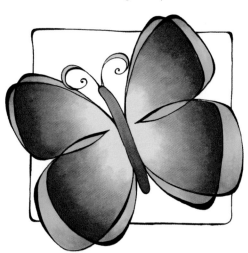

Colored with alcohol markers.
Color by Sandy Allnock.

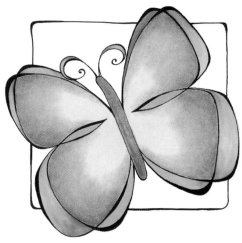

Colored with colored pencils and brush pens.

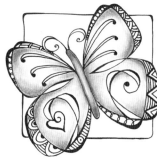

Patterned with black pen. Shaded with graphite pencil.

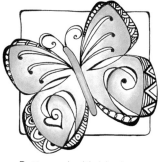

Patterned with black pen. Colored with colored pencils.

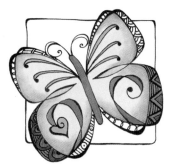

Patterned with black pen. Colored with colored pencils, gel pens, and brush pens.

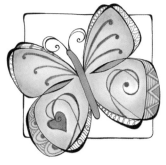

Patterned with colored pens. Colored with colored pencils, brush pens, and colored pens.

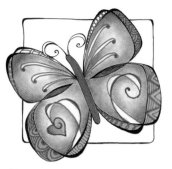

Patterned with black gel pen. Colored with colored pencils and brush pens.

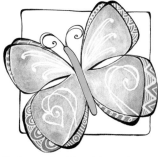

Patterned with white gel pen. Colored with water-soluble pencils and brush pens.

Special thanks to Jo-Ellen Mathews for the patterned and colored butterfly samples.

When I color my designs, I love to contrast areas of matte color with areas that shimmer and shine, and I often add touches of metallic and glitter. I gravitate toward a bright palette, but encourage you to work with whatever colors sing to your soul.

Be sure to check out the finished samples on the next few pages to see how different color and creativity enthusiasts from around the globe interpret the same design.

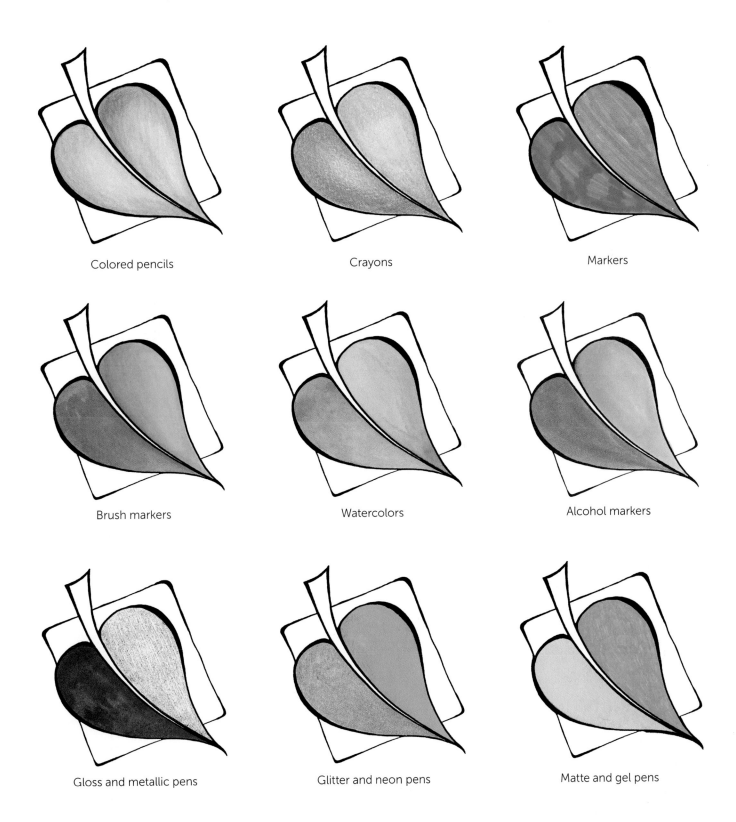

Colored pencils

Crayons

Markers

Brush markers

Watercolors

Alcohol markers

Gloss and metallic pens

Glitter and neon pens

Matte and gel pens

Pen and ink, pastel pencils, crayons.
Color & creativity by Penny Lisk.

Colored pencils, pens.
Color & creativity by Puneet Sekhon.

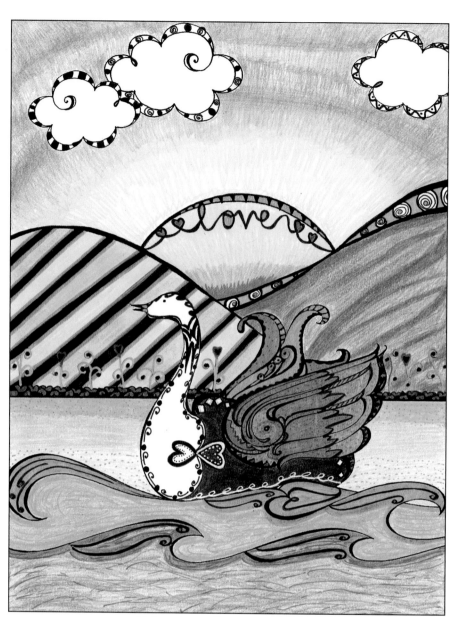

Colored pencils, pens, gel pens.
Color & creativity by Shearin Lee.

Pens, markers.
Color & creativity by Jane Tyrell.

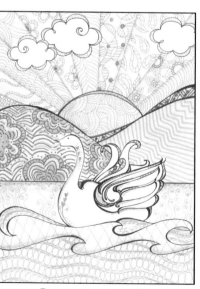

Pens, pastel pencils.
Color & creativity by Rita Barakat.

Colored pencils, brush markers.
Color & creativity by Claire Glenn.

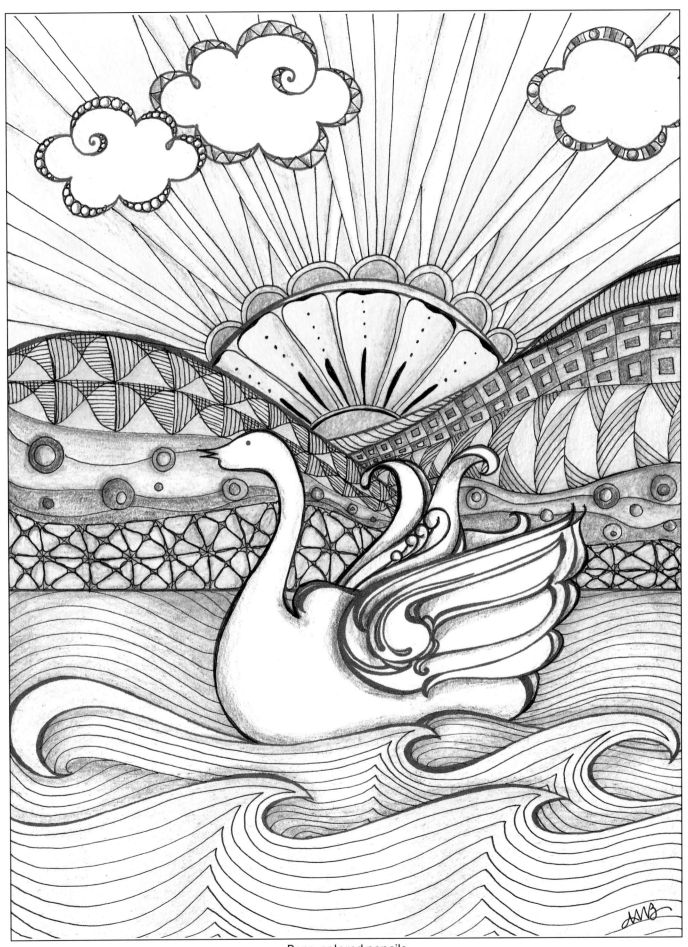

Pens, colored pencils.
Color & creativity by Adele Bruno.

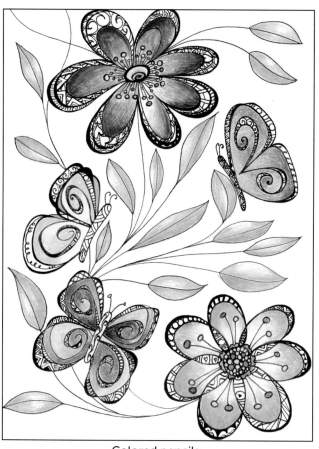

Colored pencils.
Color & creativity by Erica McPhee.

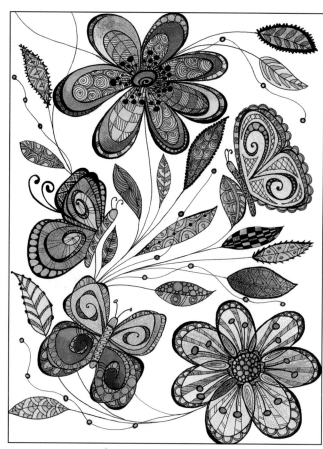

Colored pencils, pens.
Color & creativity by Terri Brown.

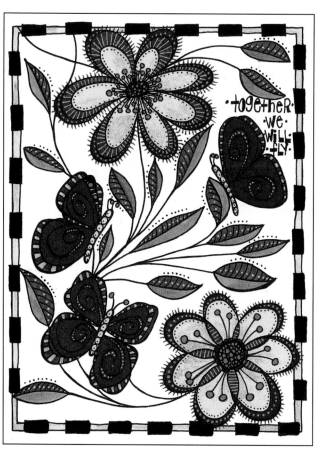

Markers, gel pens, white pen,
brush markers, paint markers.
Color & creativity by Tina Walker.

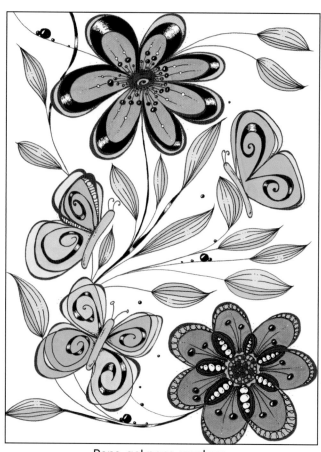

Pens, gel pens, markers.
Color & creativity by Kim Aarts.

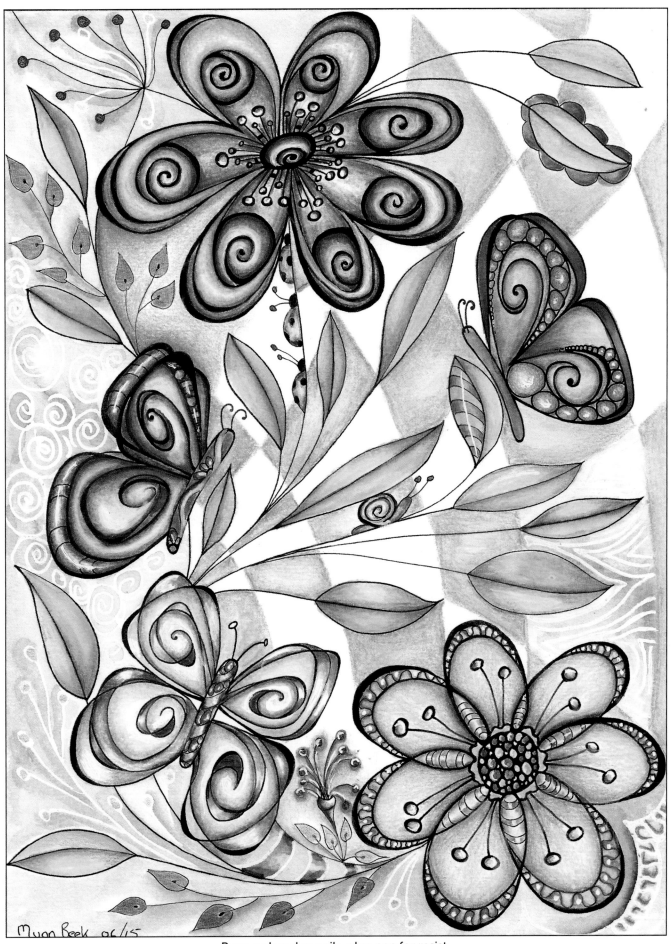

Pens, colored pencils, glue pen for resist.
Color & creativity by Marizaan van Beek.

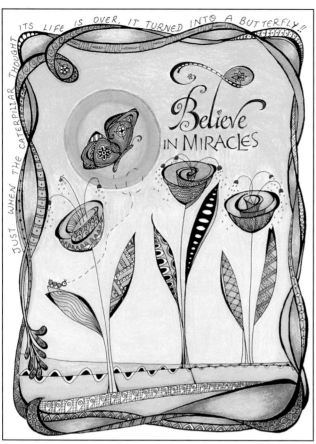

Colored pencils, gel pens, pens.
Color & creativity by Puneet Sekhon.

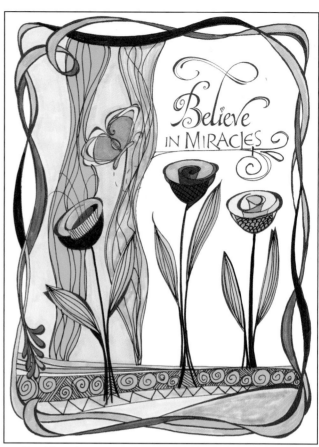

Dual brush pens, permanent marker, sand eraser.
Color & creativity by Jennifer Priest.

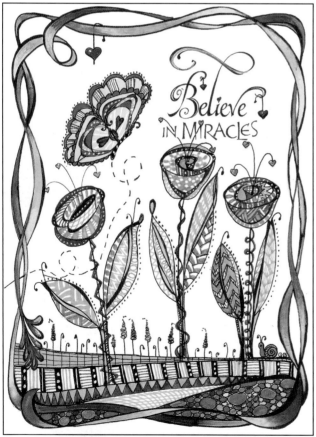

Colored pencils, gel pens, pens.
Color & creativity by Gail Beck.

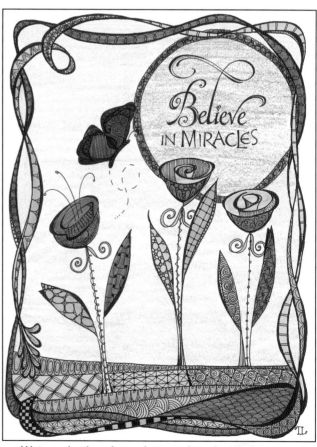

Watercolor brush markers, colored pencils, pens.
Color & creativity by Tracey Lyon.

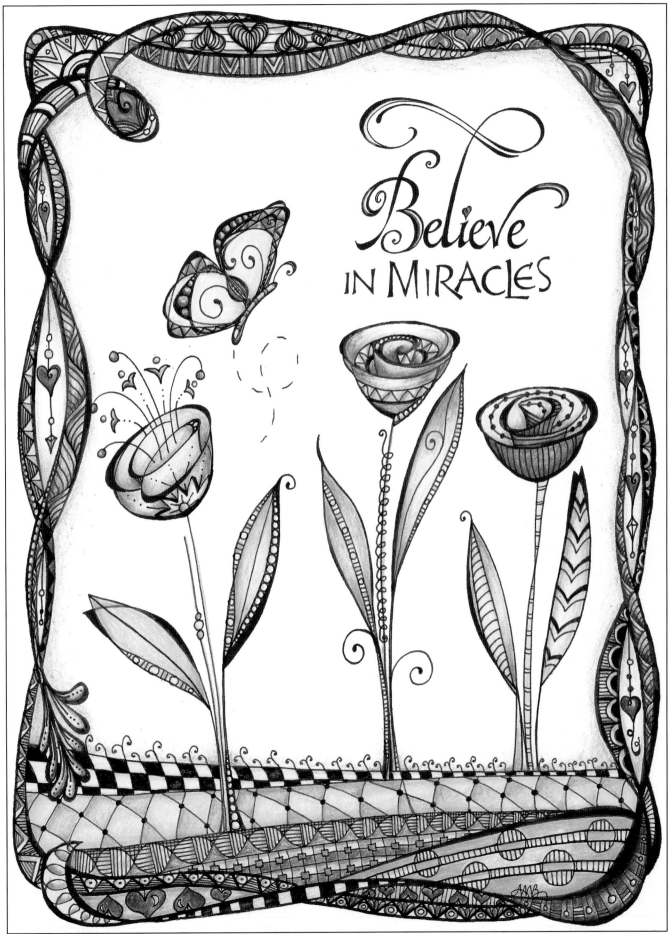

Pens, colored pencils.
Color & creativity by Adele Bruno.

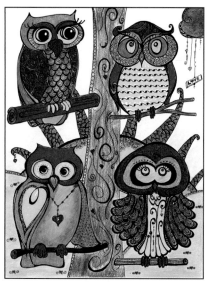

Pens, markers, colored pencils.
Color & creativity by Regina Yoder.

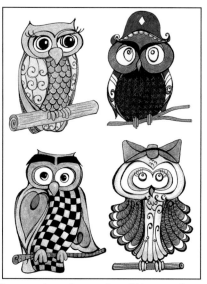

Pens, colored pencils, glitter markers,
markers, glue pen.
Color & creativity by Karen Stellema.

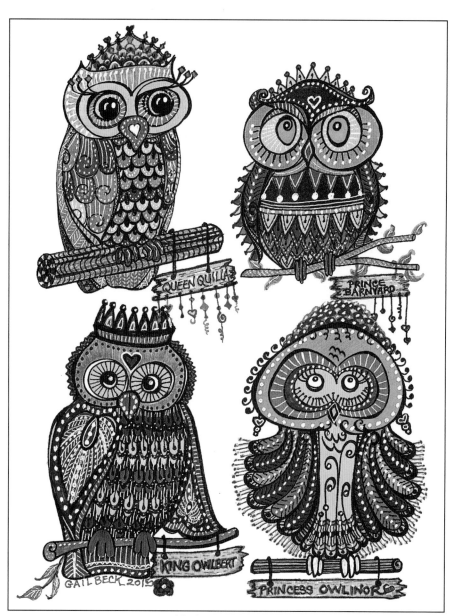

Markers, gel pens.
Color & creativity by Gail Beck.

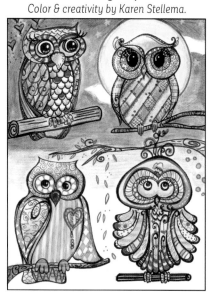

Pens, pastel pencils.
Color & creativity by Rita Barakat.

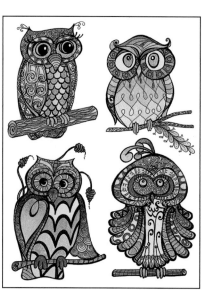

Colored pencils, pens.
Color & creativity by Terri Brown.

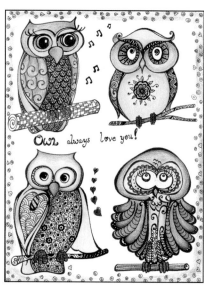

Colored pencils, gel pens, pens.
Color & creativity by Puneet Sekhon.

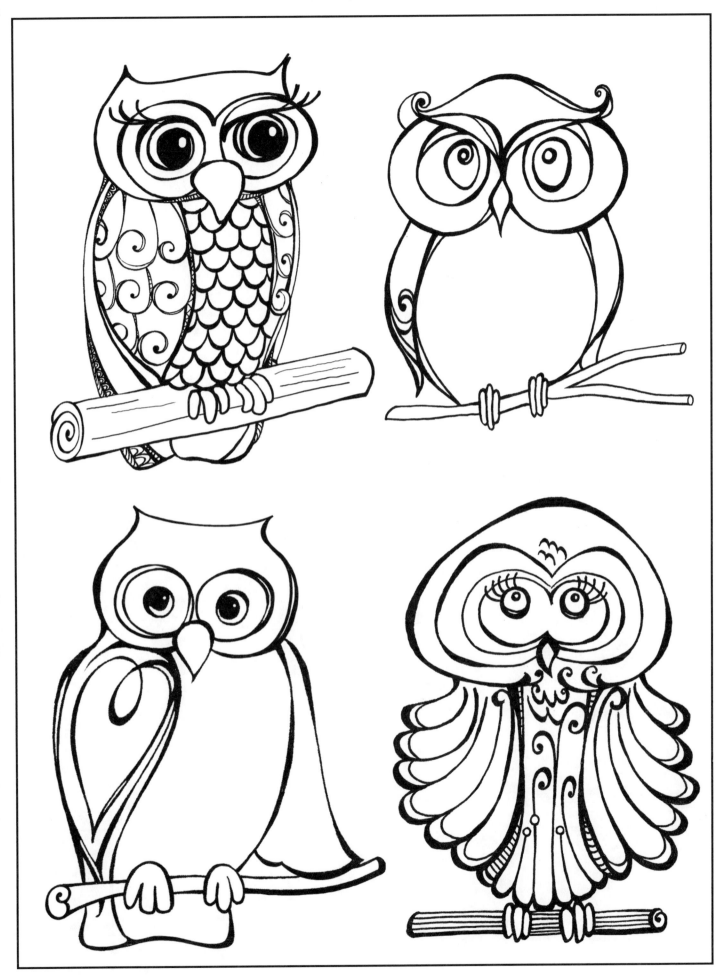

COLOR & CREATIVITY BY_____

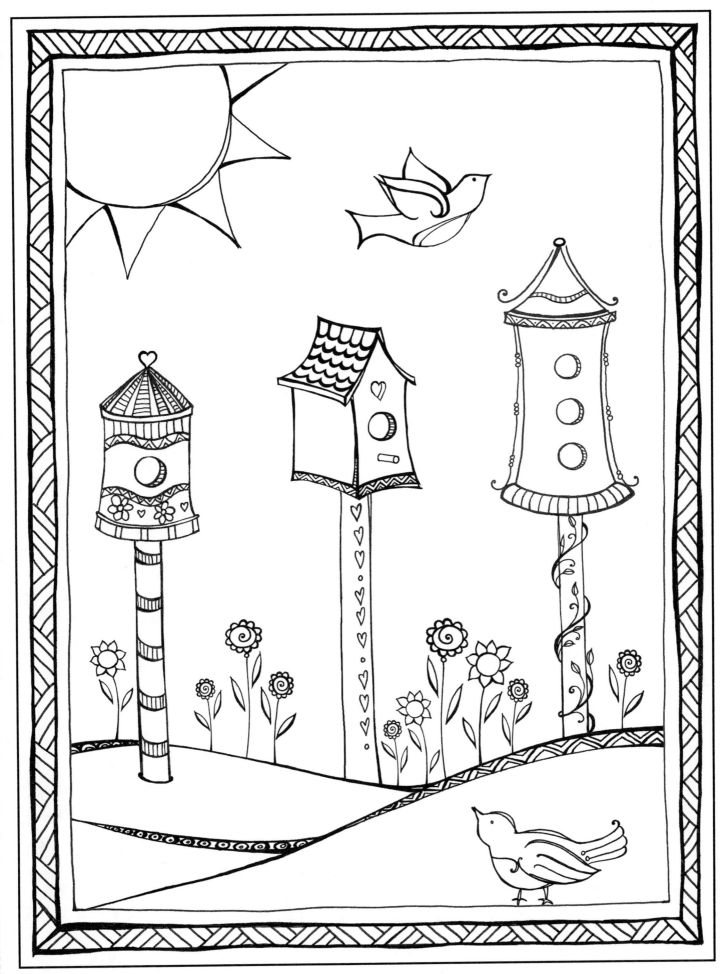

COLOR & CREATIVITY BY_____

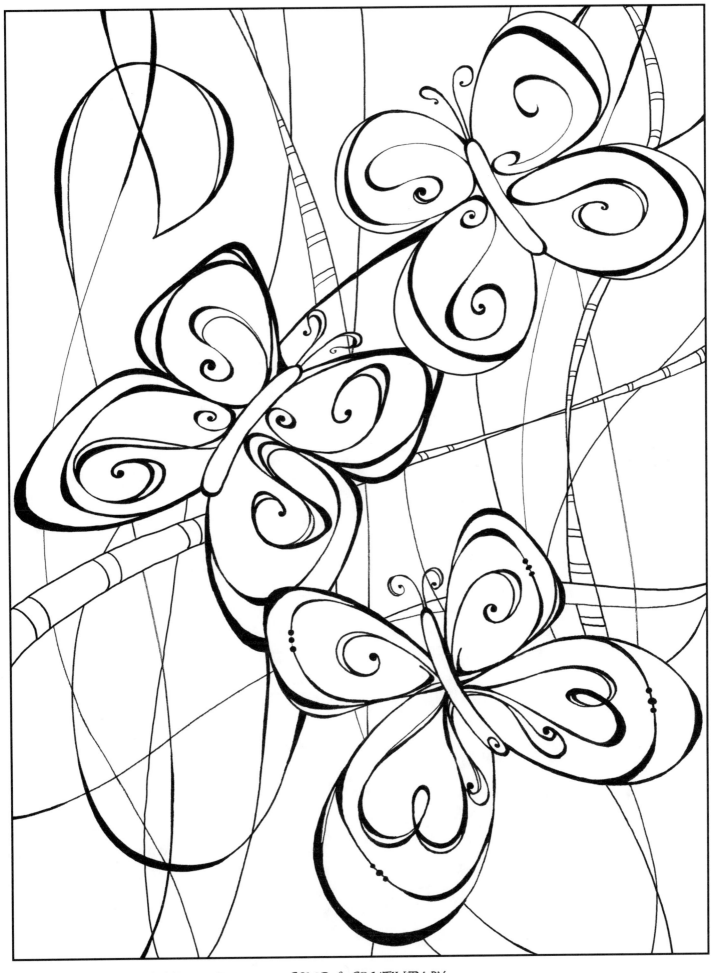

COLOR & CREATIVITY BY_____

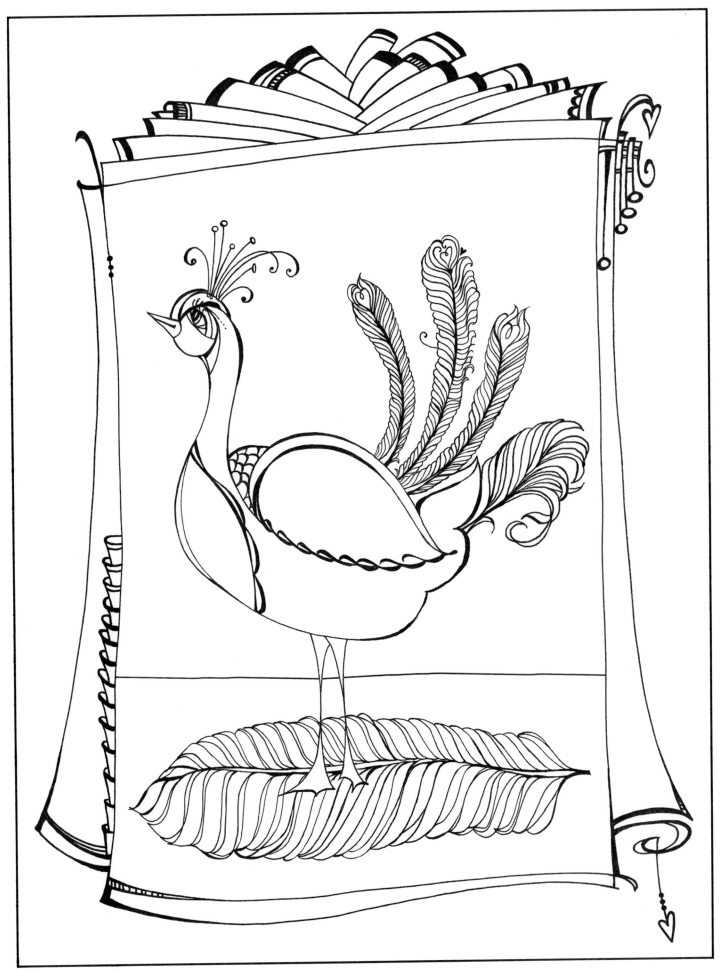

COLOR & CREATIVITY BY_____

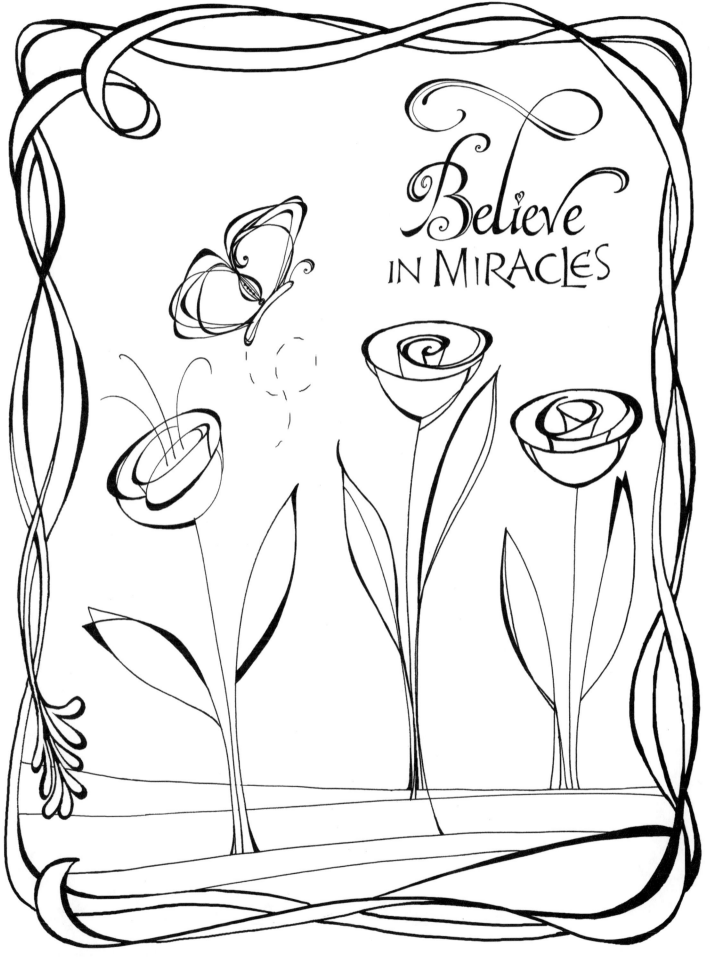

Believe in Miracles

©JOANNE FINK • WWW.ZENSPIRATIONS.COM COLOR & CREATIVITY BY_____

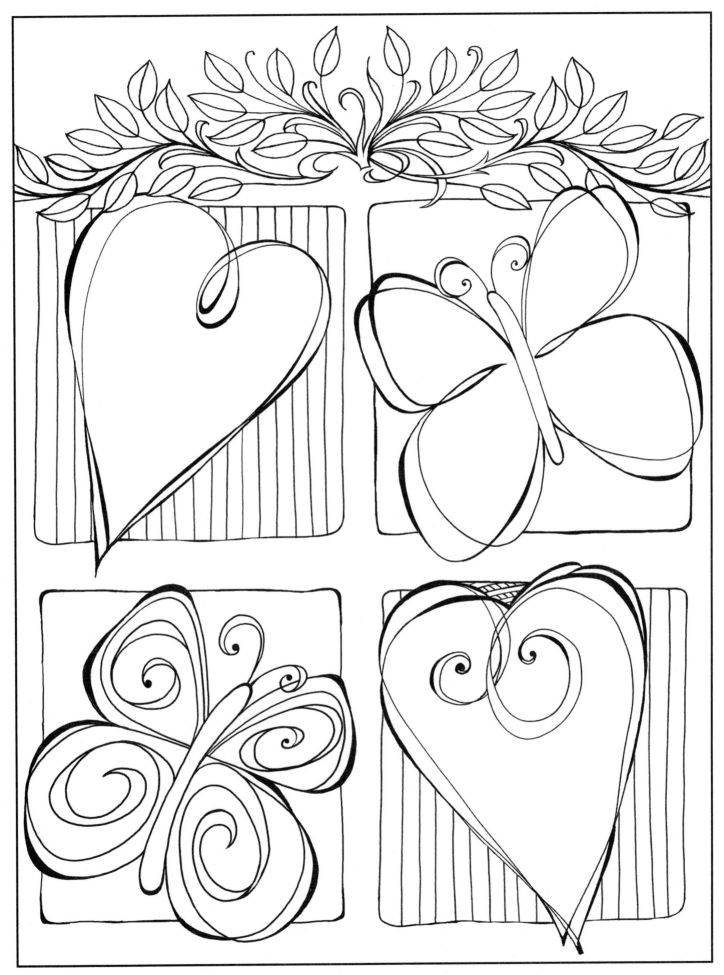

COLOR & CREATIVITY BY_____

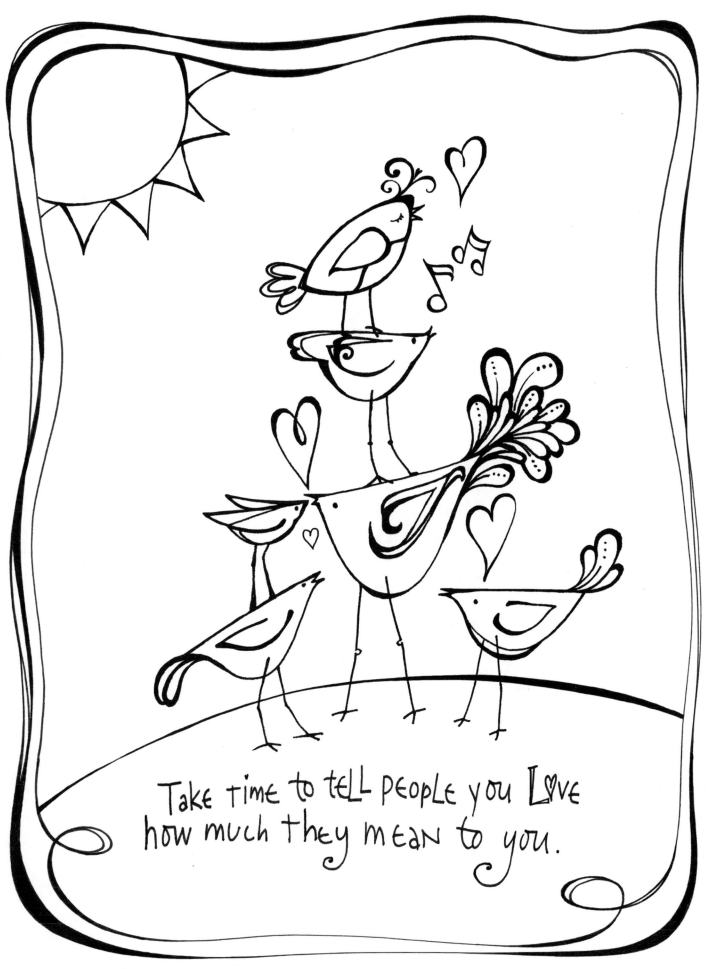

Take time to tell people you Love how much they mean to you.

COLOR & CREATIVITY BY_____

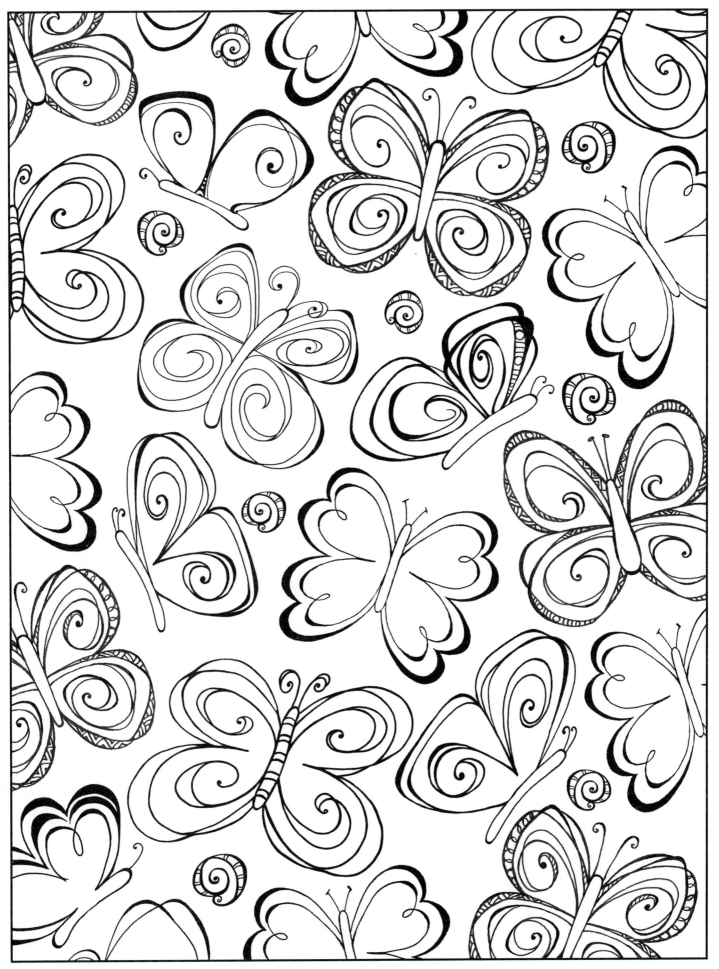

COLOR & CREATIVITY BY_____

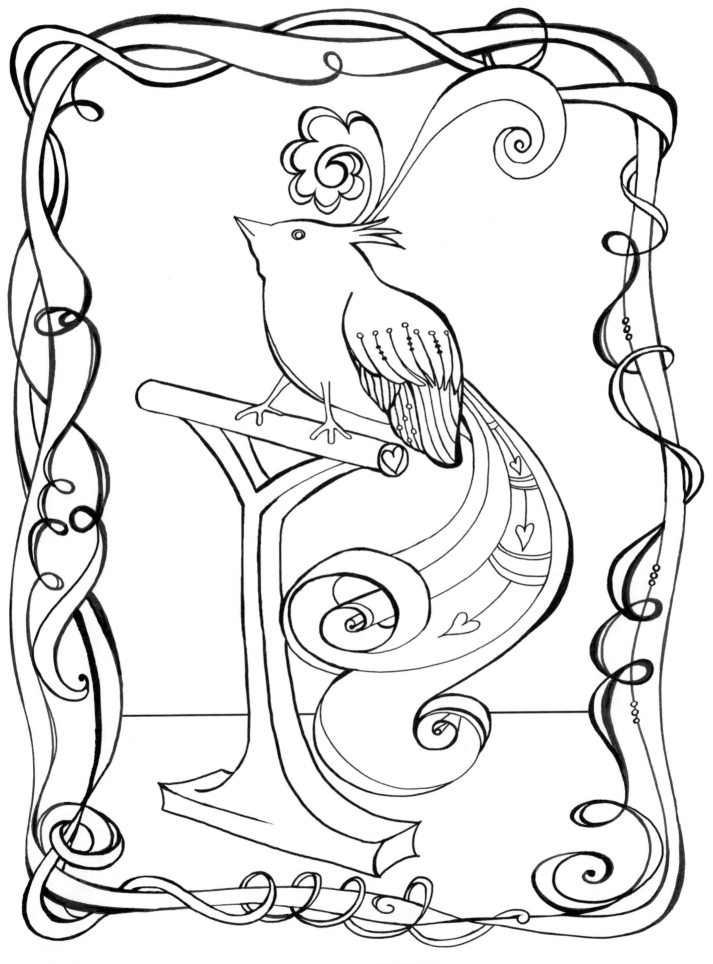

COLOR & CREATIVITY BY_____

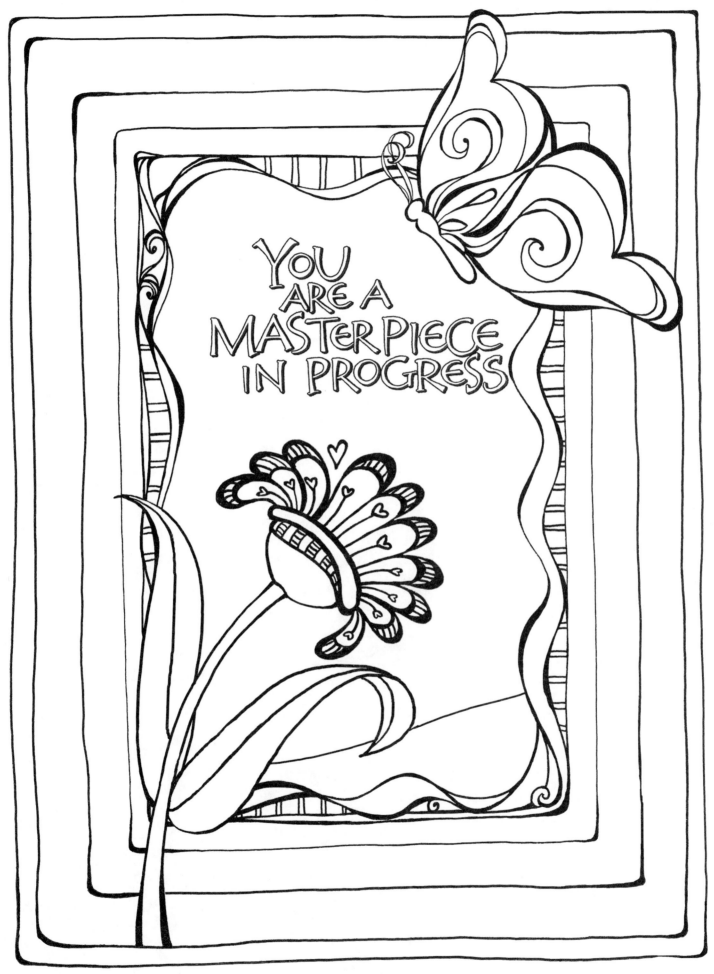

You are a MASTERPIECE in PROGRESS

COLOR & CREATIVITY BY

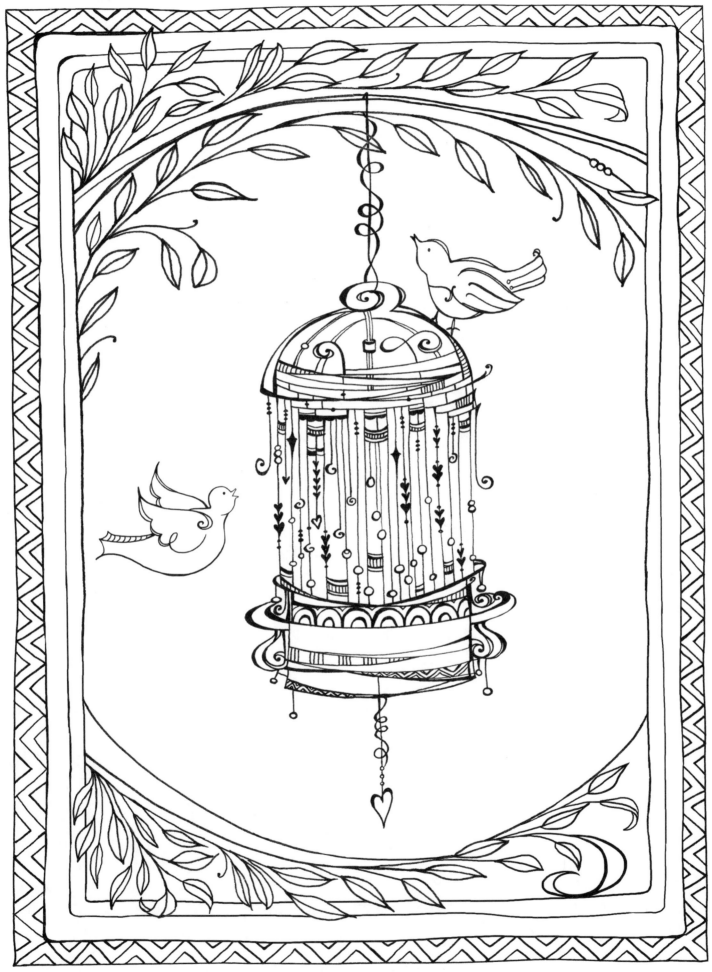

Color & Creativity by _____

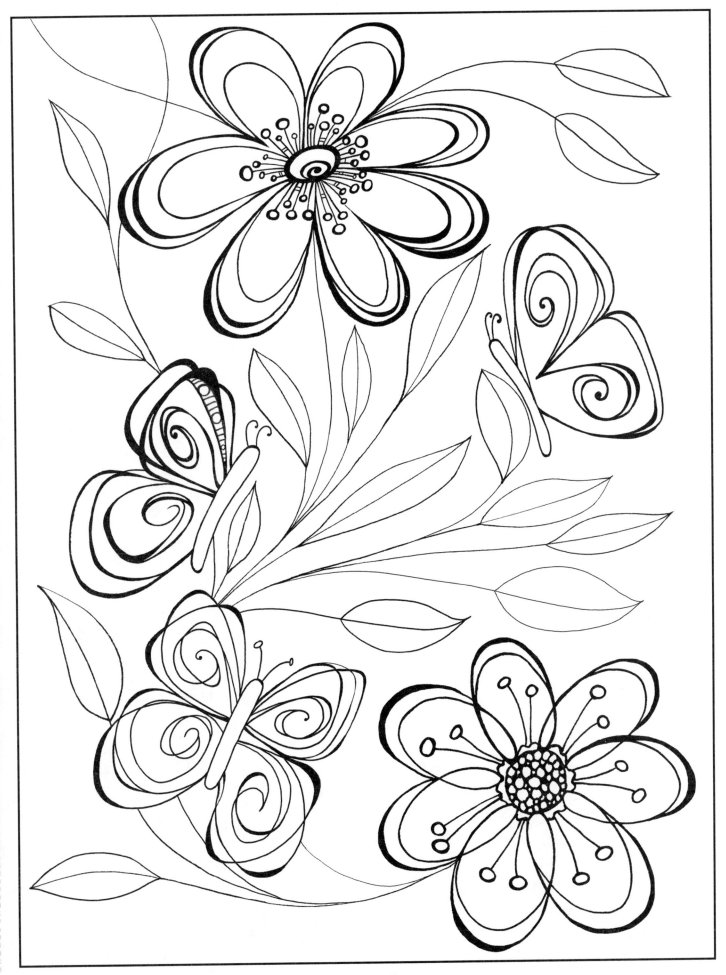

COLOR & CREATIVITY BY_____

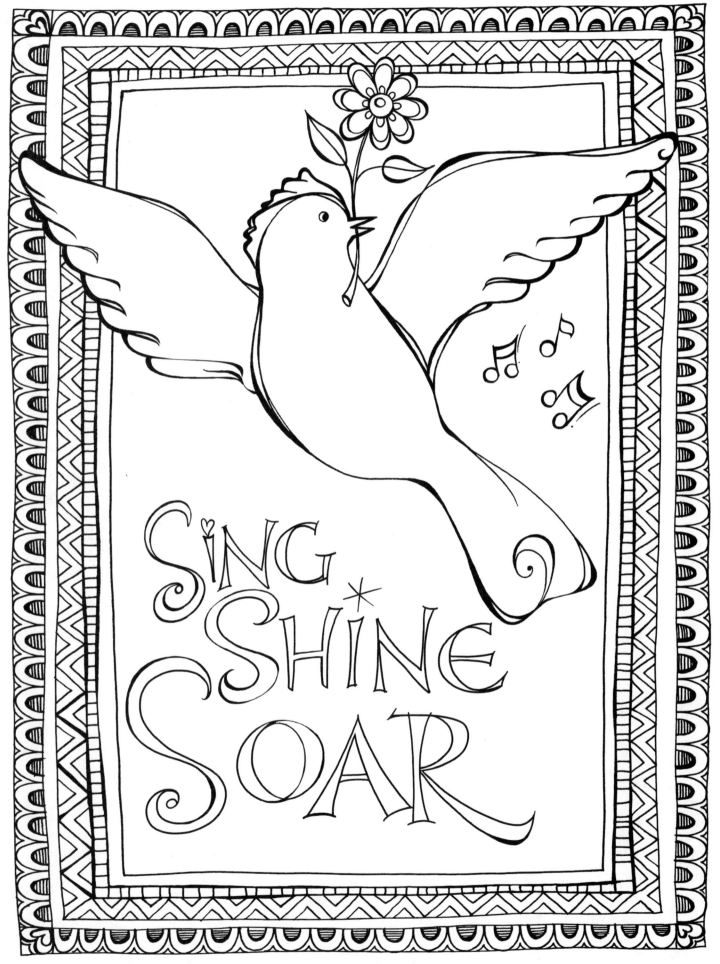

Sing
Shine
Soar

COLOR & CREATIVITY BY_____

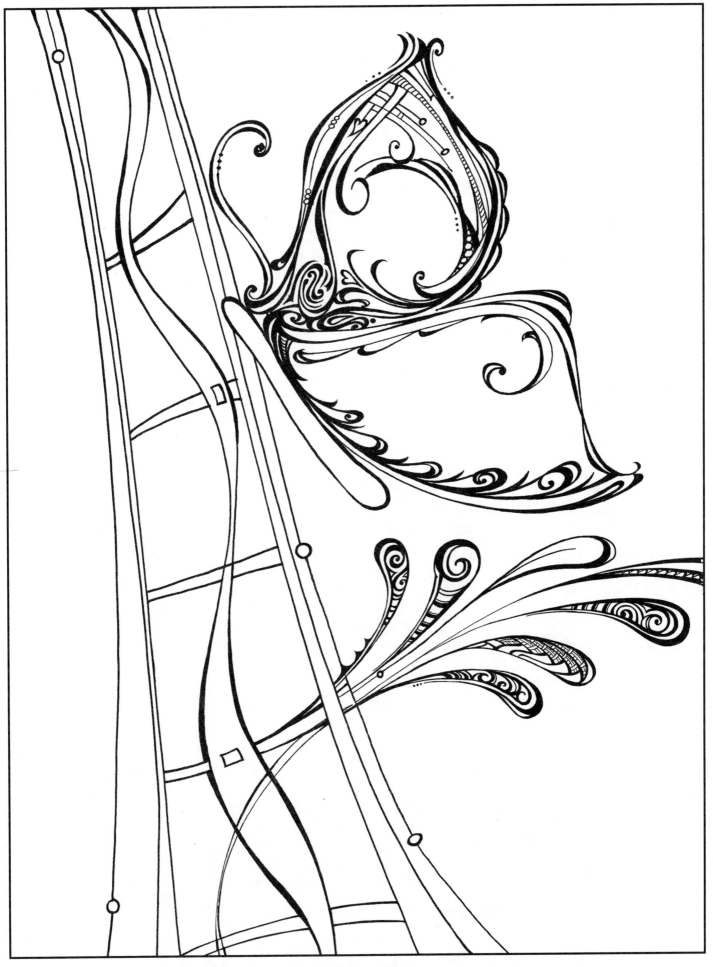

COLOR & CREATIVITY BY

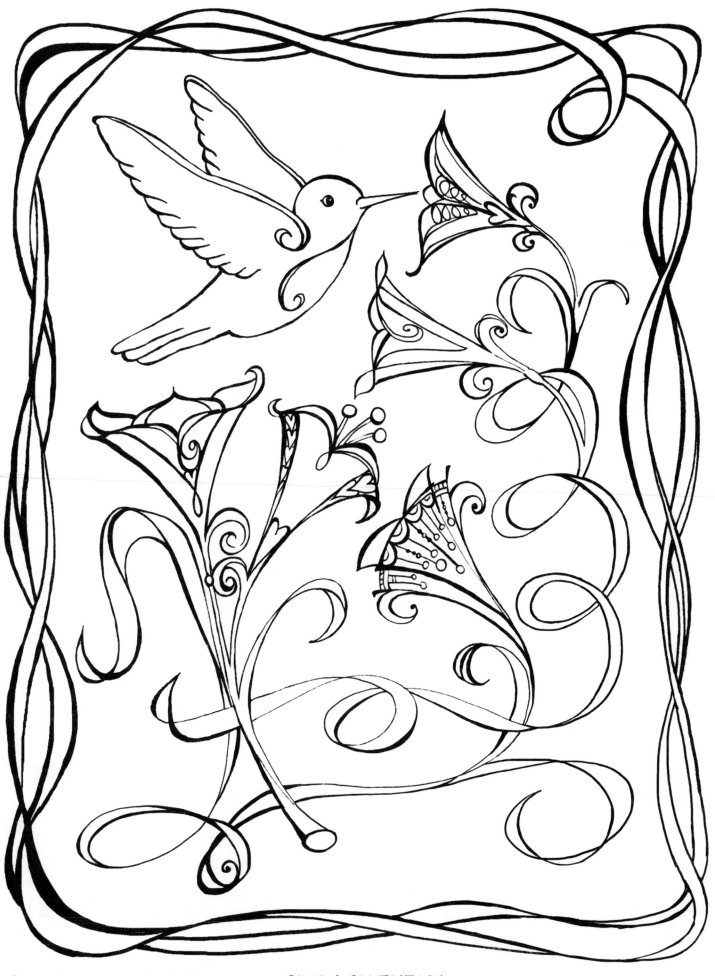

COLOR & CREATIVITY BY_____

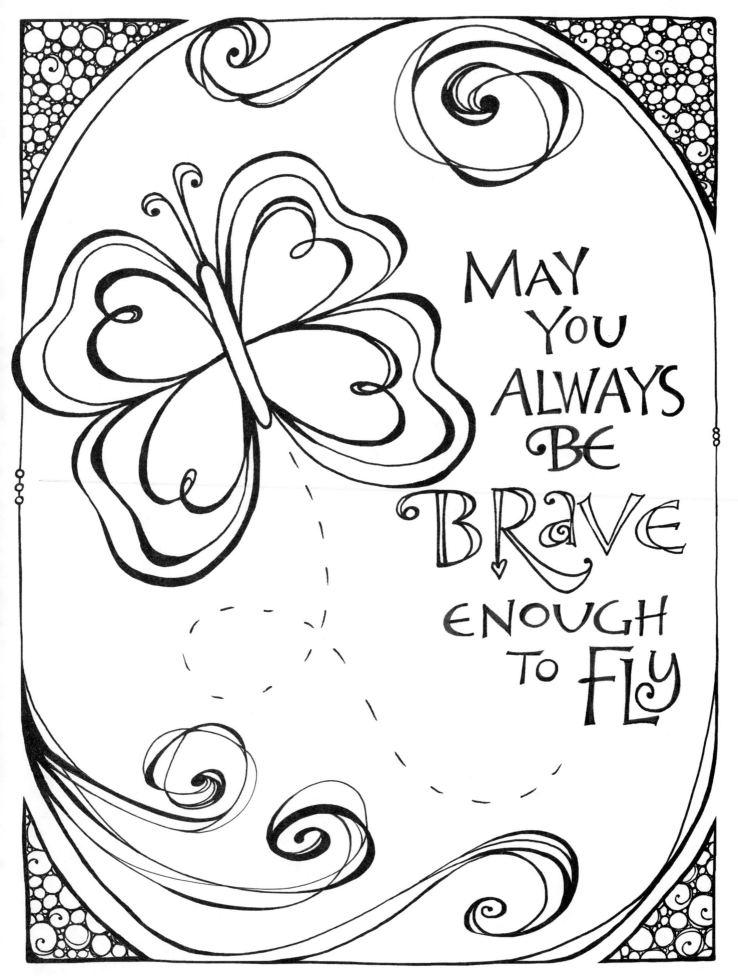

MAY YOU ALWAYS BE BRAVE ENOUGH TO FLY

©JOANNE FINK·WWW.ZENSPIRATIONS.COM COLOR & CREATIVITY BY_____

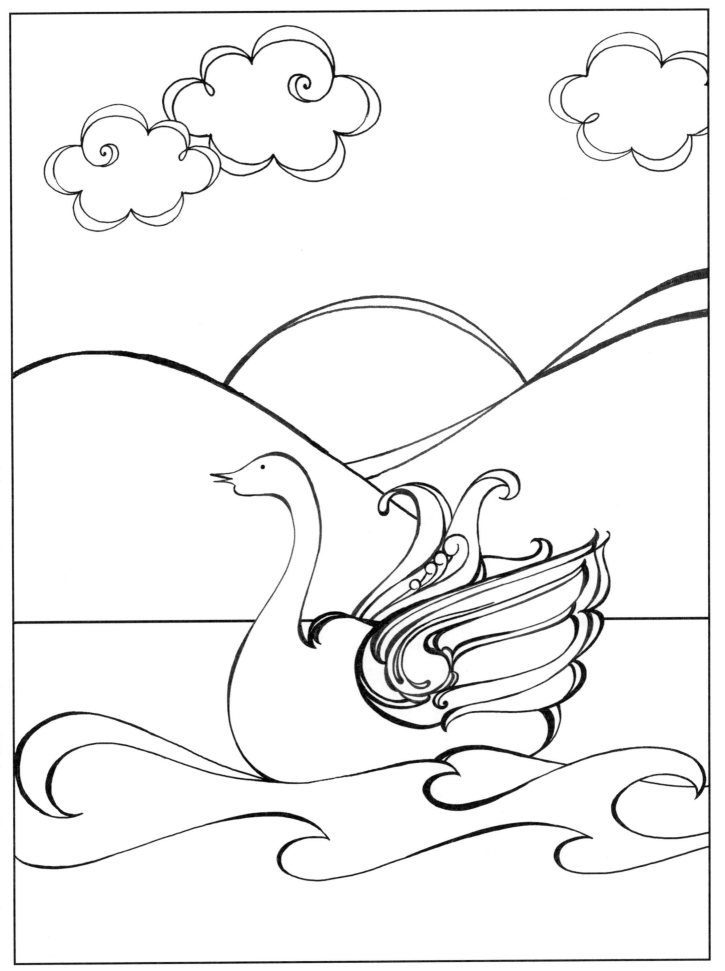

COLOR & CREATIVITY BY_____

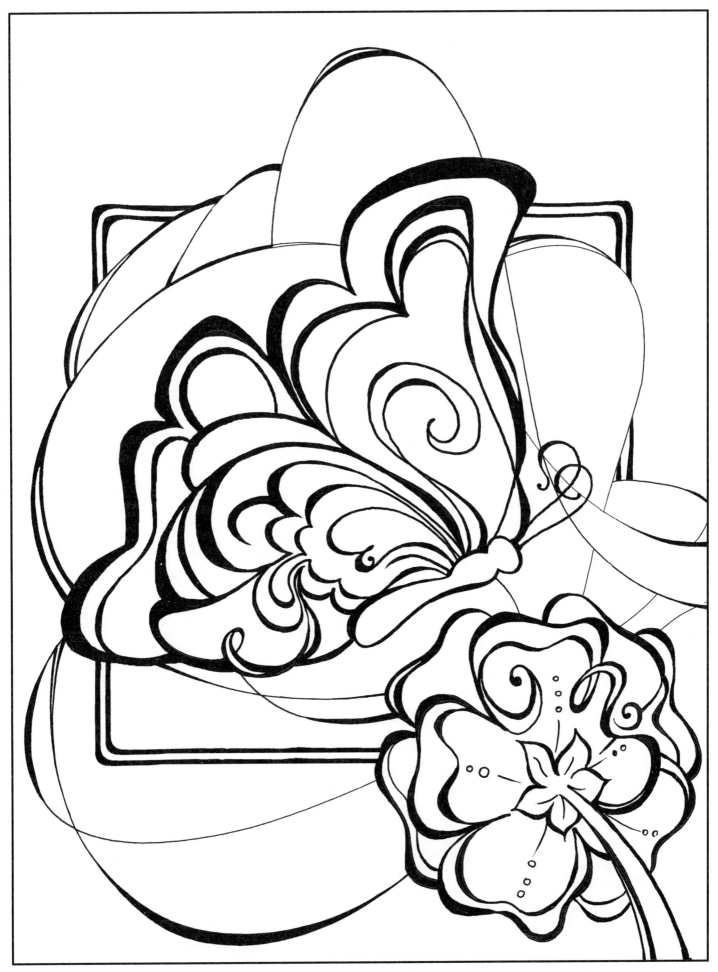

COLOR & CREATIVITY BY_____

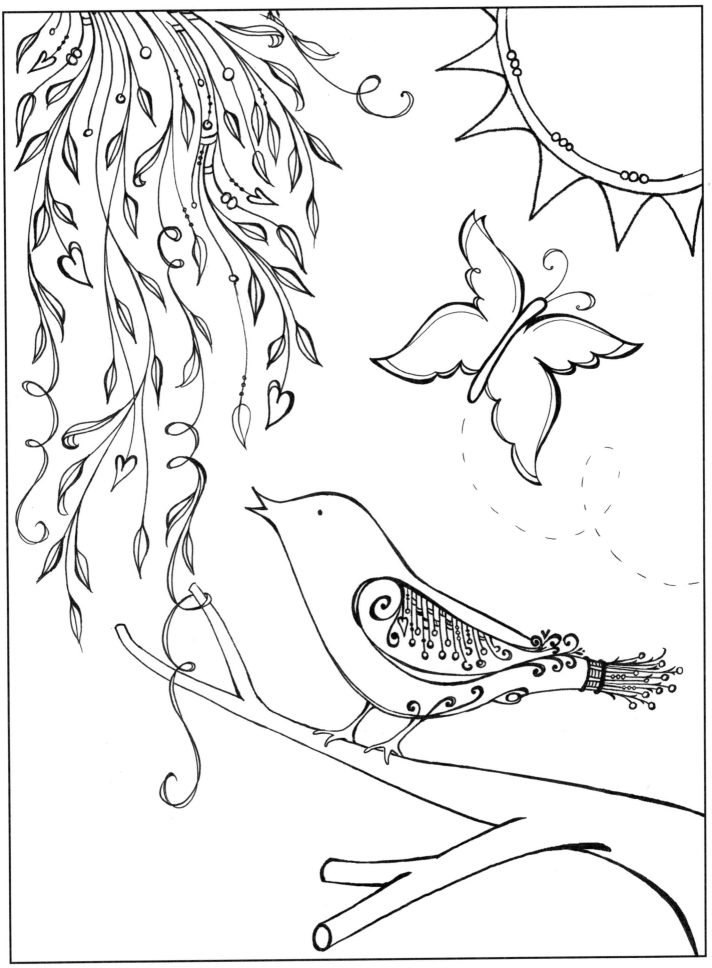

COLOR & CREATIVITY BY_____

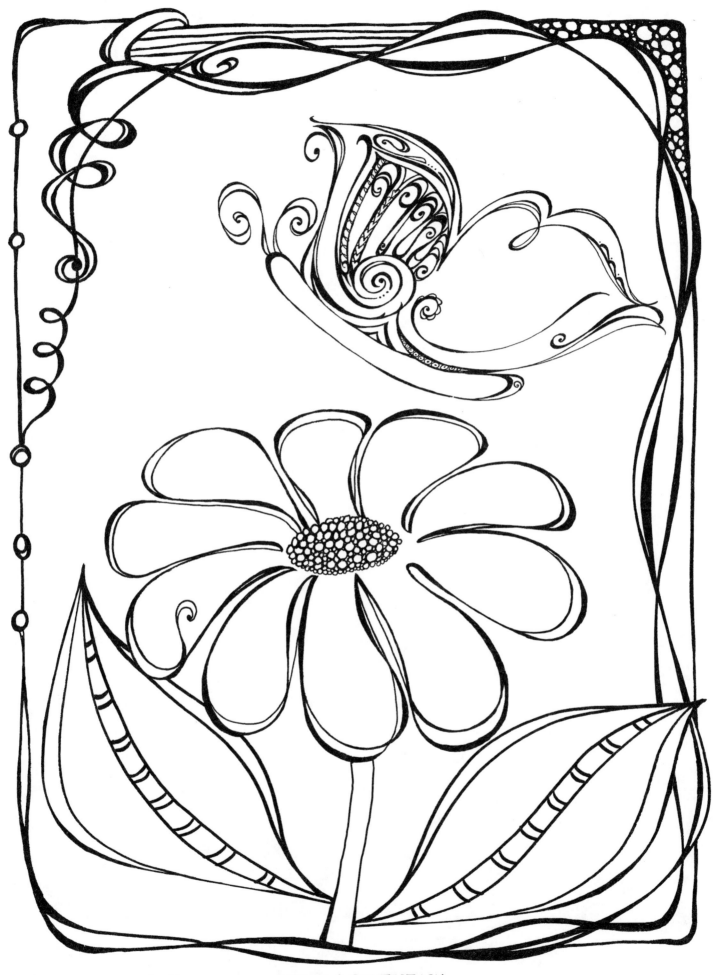

COLOR & CREATIVITY BY

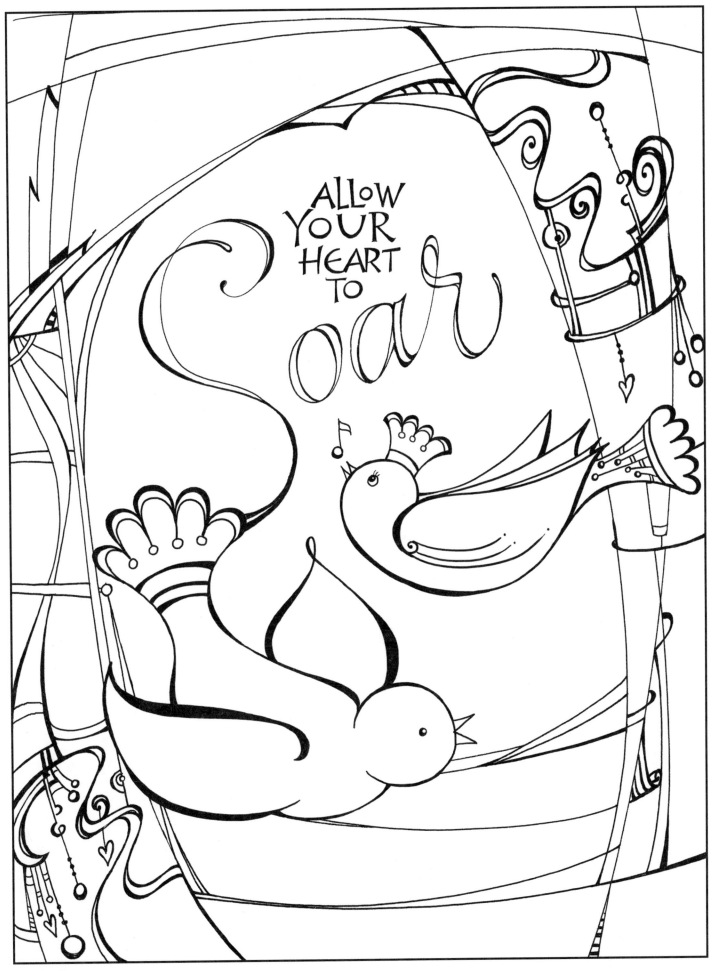

COLOR & CREATIVITY BY _____

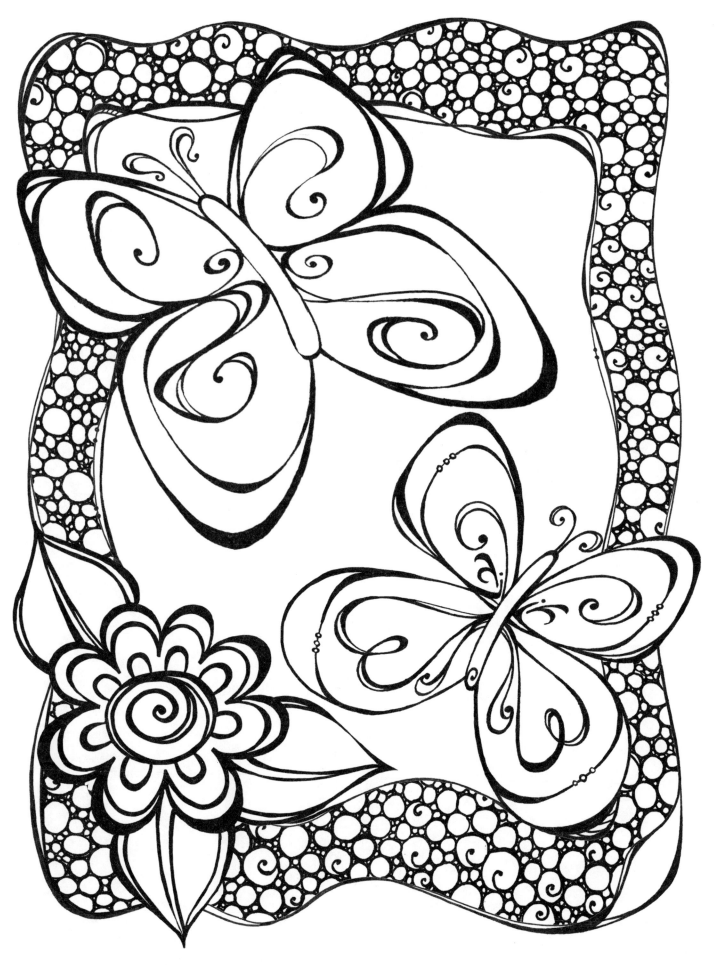

COLOR & CREATIVITY BY_____

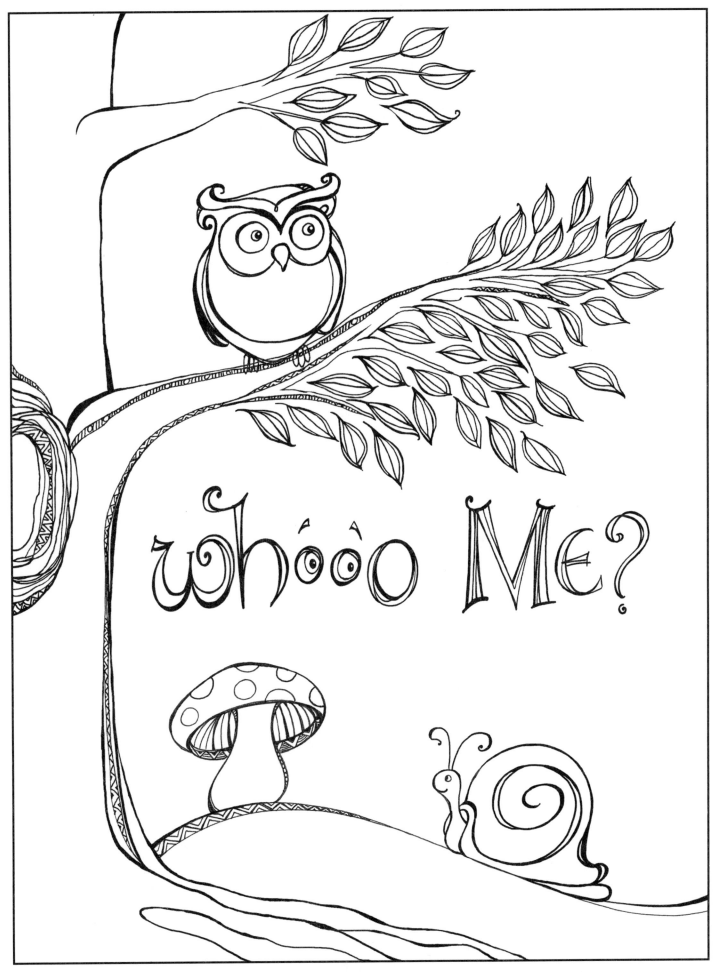

wh○○○○ Me?

COLOR & CREATIVITY BY _____

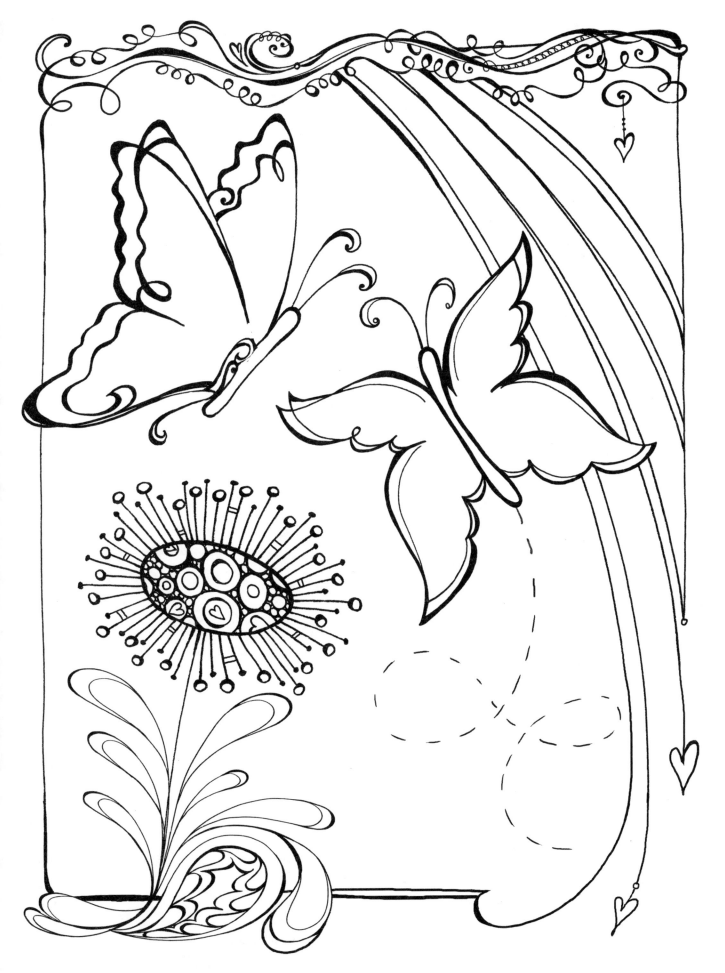

COLOR & CREATIVITY BY

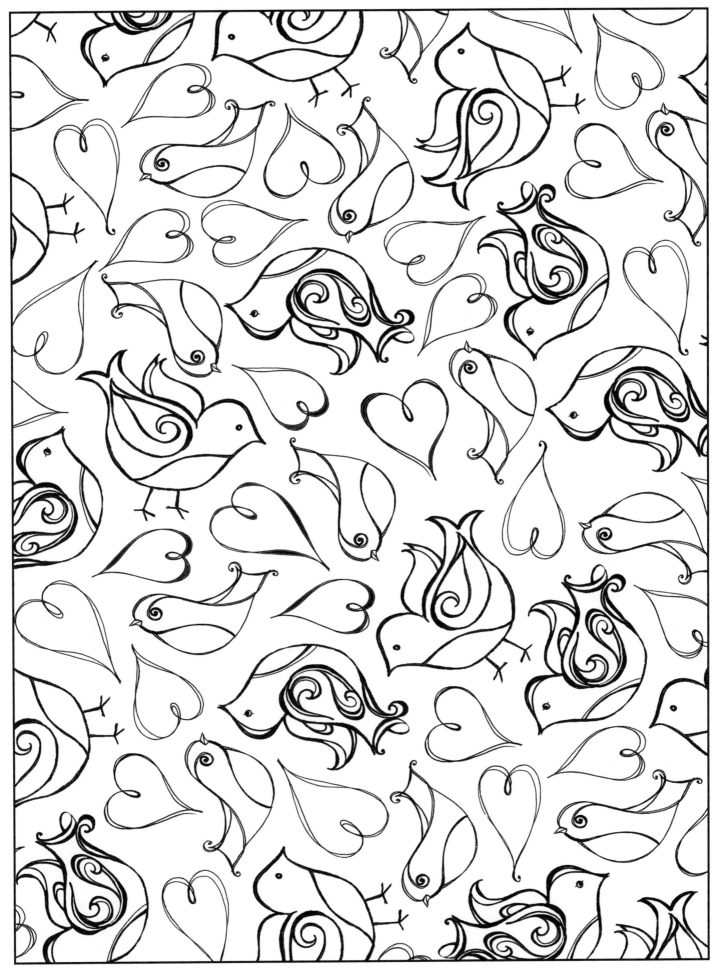

COLOR & CREATIVITY BY_____

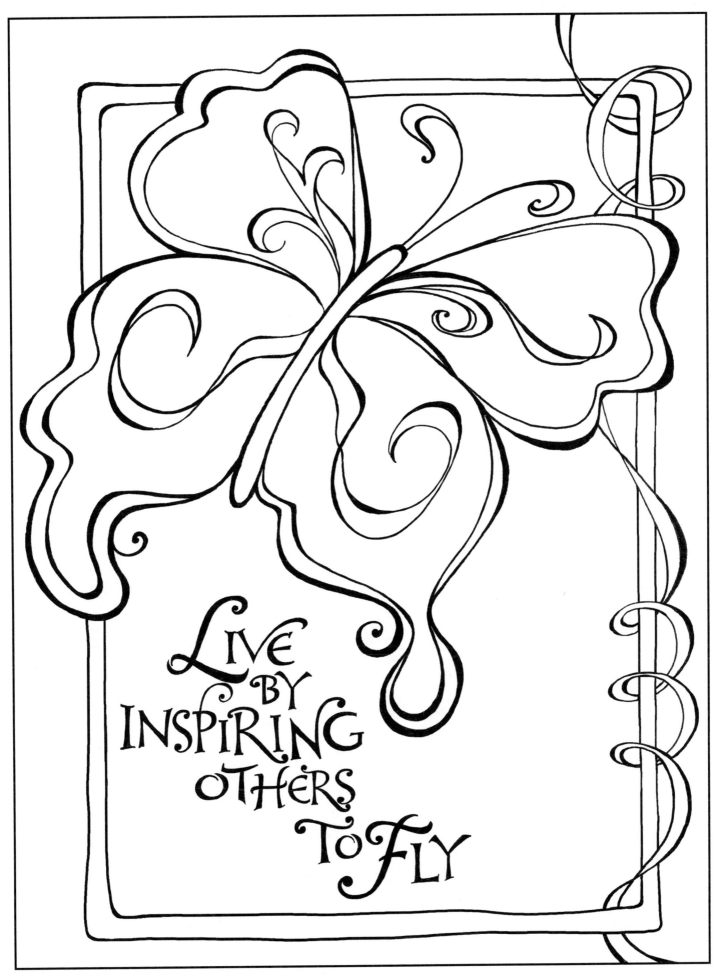

LIVE
BY
INSPIRING
OTHERS
TO FLY

COLOR & CREATIVITY BY

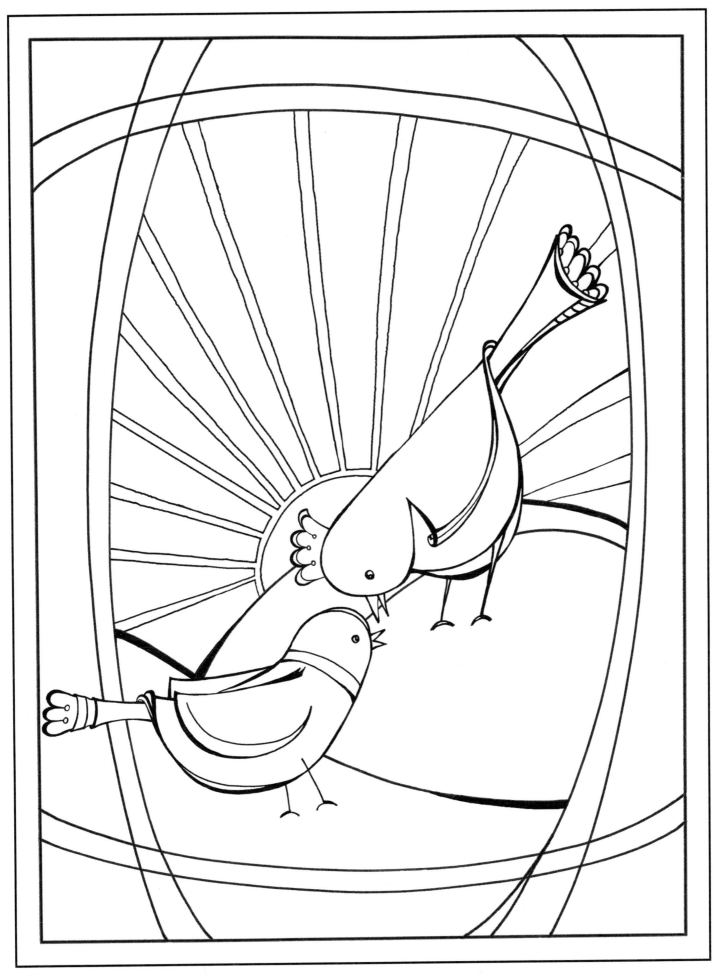

COLOR & CREATIVITY BY

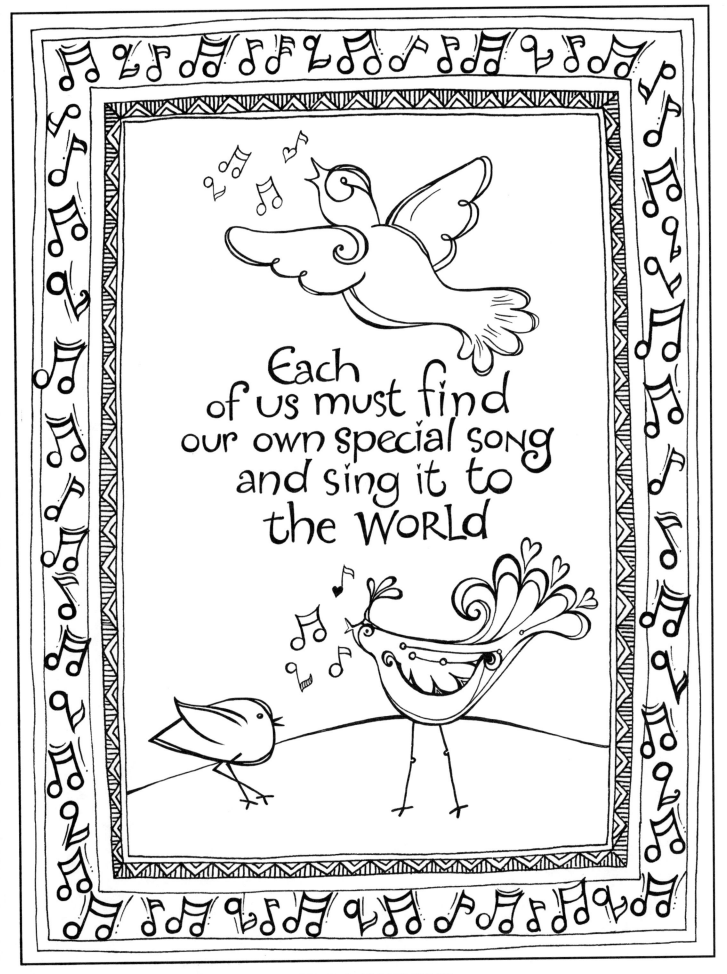

Each
of us must find
our own special song
and sing it to
the WORLD

COLOR & CREATIVITY BY_____

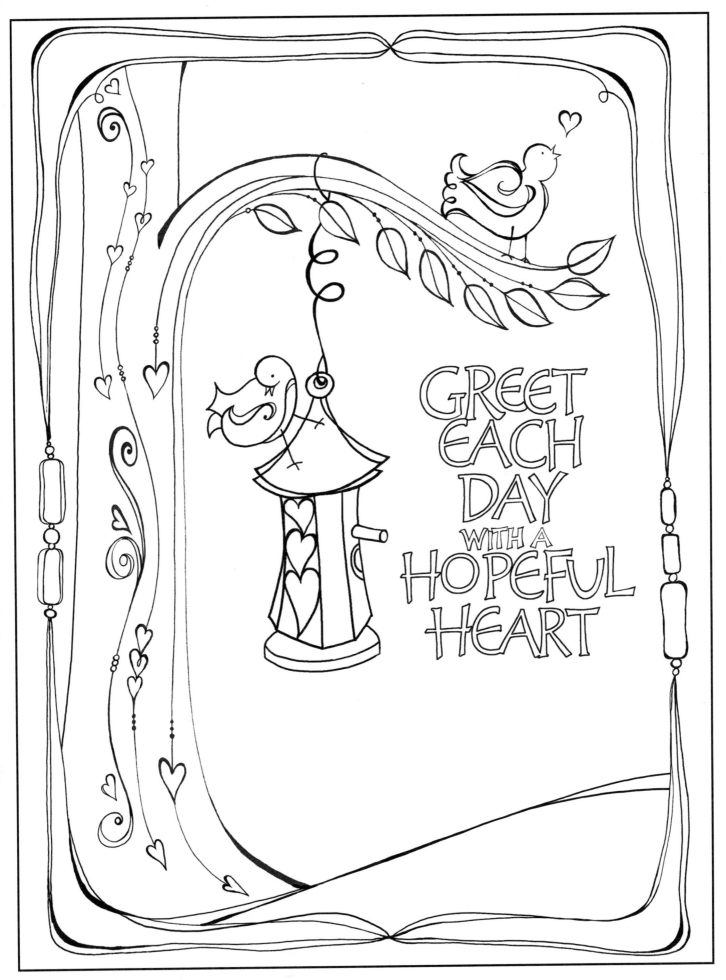

GREET EACH DAY WITH A HOPEFUL HEART

COLOR & CREATIVITY BY_____

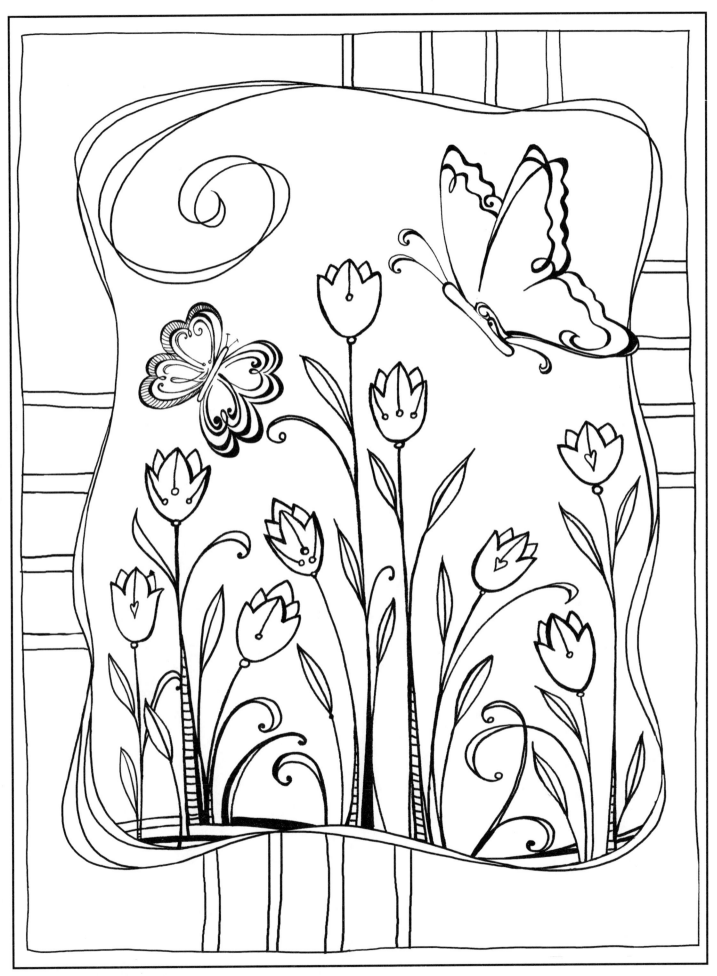

COLOR & CREATIVITY BY_____

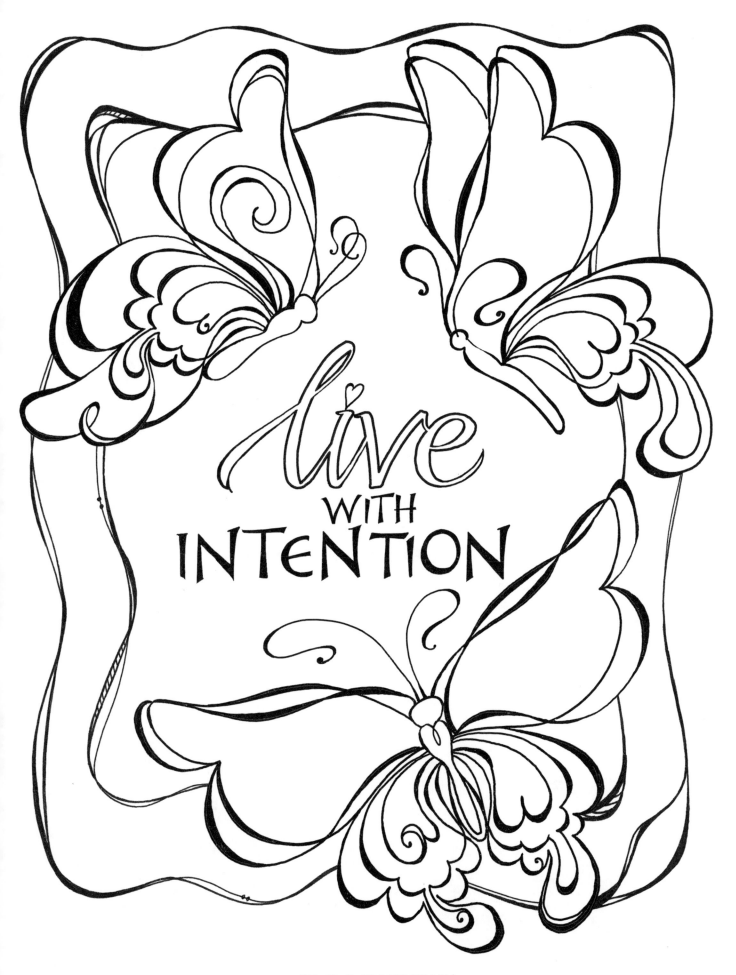

live
WITH
INTENTION

COLOR & CREATIVITY BY_____

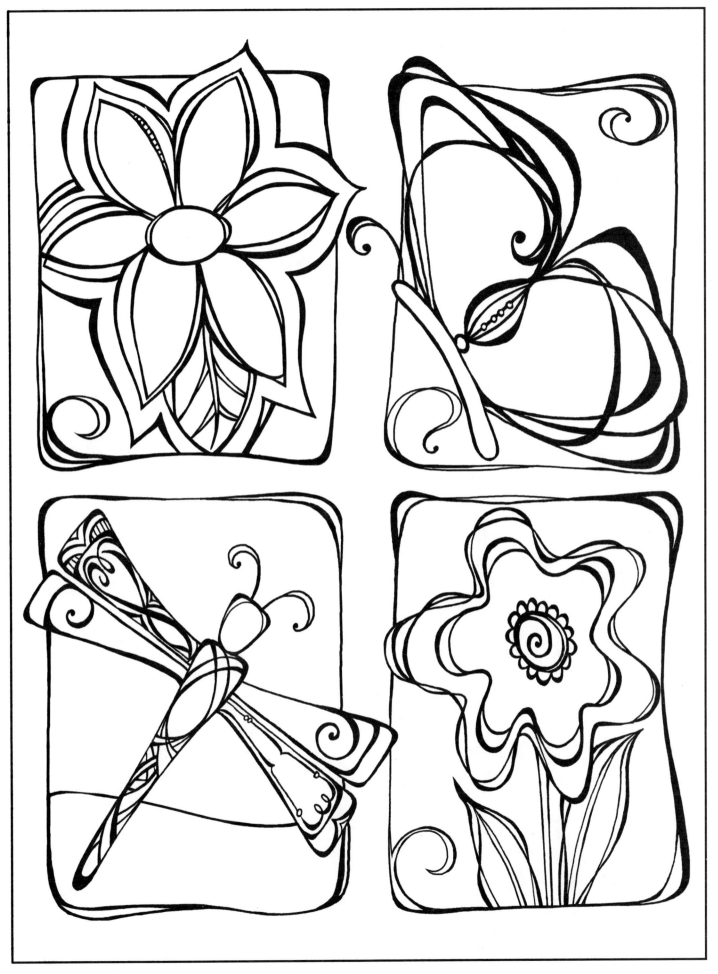

COLOR & CREATIVITY BY